HORACE PIPPIN

Painter and Decorated Soldier

Celebrating

BLACK ARTISTS

HORACE PIPPIN

Painter and Decorated Soldier

Enslow Publishing
101 W. 23rd Street
Suite 240
New York, NY 10011
USA
enslow.com

CHARLOTTE ETINDE-CROMPTON AND
SAMUEL WILLARD CROMPTON

Published in 2020 by Enslow Publishing, LLC.
101 W. 23rd Street, Suite 240, New York, NY 10011

Copyright © 2020 by Enslow Publishing, LLC.

All rights reserved.

No part of this book may be reproduced by any means without the written permission of the publisher.

Library of Congress Cataloging-in-Publication Data

Names: Crompton, Samuel Willard, author. | Etinde-Crompton, Charlotte, author.
Title: Horace Pippin : painter and decorated soldier / Samuel Willard Crompton and Charlotte Etinde-Crompton.
Description: New York : Enslow Publishing, [2020] | Series: Celebrating black artists | Includes bibliographical references and index. | Audience: Grades 7–12.
Identifiers: LCCN 2018015695| ISBN 9781978503601 (library bound) | ISBN 9781978505353 (pbk.).
Subjects: LCSH: Pippin, Horace, 1888-1946—Juvenile literature. | African American painters—Biography—Juvenile literature. | World War, 1914-1918—Art and the war—Juvenile literature. | United States. Army. Infantry Regiment, 369th—Biography—Juvenile literature. | African American soldiers—Biography—Juvenile literature. | Disabled veterans—United States—Biography—Juvenile literature. | World War, 1914–1918—Participation, African American—Juvenile literature.
Classification: LCC ND237.P65 C66 2018 | DDC 759.13—dc23
LC record available at https://lccn.loc.gov/2018015695

Printed in China

To Our Readers: We have done our best to make sure all website addresses in this book were active and appropriate when we went to press. However, the author and the publisher have no control over and assume no liability for the material available on those websites or on any websites they may link to. Any comments or suggestions can be sent by e-mail to customerservice@enslow.com.

Photo Credits: Cover, pp. 3, 84 Everett Art/Shutterstock.com; p. 6 HT777/Alamy Stock Photo; pp. 10–11 Cincinnati Art Museum, Ohio, USA/The Edwin and Virginia Irwin Memorial/Bridgeman Images; pp.14–15, 20 Buyenlarge/Archive Photos/Getty Images; pp. 22–23 Mirrorpix/Getty Images; pp. 26–27 Corbis Historical/Getty Images; p. 31 FPG/Archive Photos/Getty Images; pp. 36–37 Bequest of Jane Kendall Gingrich, 1982/The Met; pp. 40–41 Philadelphia Museum of Art, Pennsylvania, PA, USA/Gift of Robert Carlen/Bridgeman Images; pp. 44–45 American Folk Art Museum/Art Resource, NY; pp. 46–47 Everett Historical/Shutterstock.com; pp. 50–51 Indianapolis Museum of Art at Newfields, USA/Gift of the Harrison Eiteljorg Gallery of Western Art by exchange, James E. Roberts Fund, Mr. and Mrs. C. Severin Buschmann, Jr. Fund/Bridgeman Images; pp. 52–53 The Art Institute of Chicago, IL, USA/Restricted gift in memory of Frances W. Pick from her children Thomas F. Pick and Mary P. Hines/Bridgeman Images; pp. 54–55, 66–67, 78–79 The Barnes Foundation, Philadelphia, Pennsylvania, USA/Bridgeman Images; p. 59 Philadelphia Museum of Art, Pennsylvania, PA, USA/Bridgeman Images; pp. 62–63 Digital Image © The Museum of Modern Art/Licensed by SCALA/Art Resource, NY; pp. 64–65 The Phillips Collection, Washington, D.C., USA/Acquired 1943/Bridgeman Images; p. 70 Albright-Knox Art Gallery/Art Resource, NY; pp. 72–73 Image copyright © The Metropolitan Museum of Art. Image source: Art Resource, NY; p. 81 Philadelphia Museum of Art, Pennsylvania, PA, USA/Gift of Dr & Mrs Matthew T. Moore, 1984/Bridgeman Images; pp. 86–87 Allen Memorial Art Museum, Oberlin College, Ohio, USA/Gift of Joseph and Enid Bissett/Bridgeman Images.

Contents

1. The Youth of an Artist 7
2. Life as a Black Soldier 14
3. The Most Traumatic Day 22
4. A Painful Return 30
5. Painting the War 39
6. An Evolving Style 49
7. Road to Discovery 58
8. Dealing with Race 69
9. Troubles at Home 77
10. A Sudden End 86

Chronology ... 93
Chapter Notes 96
Glossary .. 98
Further Reading 99
Select List of Works 100
Index .. 101
About the Authors 104

Though he was born in West Chester, Pennsylvania, Horace Pippin did not spend significant time there until he returned as an adult.

Chapter

The Youth of an Artist

Horace Pippin's early life was uniformly average for an African American male. Nothing in his background suggested he would become a renowned artist. But his great talent—his skill with a brush—took him to the top of his field.

Drawing and Discipline

Horace Pippin was born in West Chester, Pennsylvania, on February 22, 1888, which also happened to be the seventy-ninth anniversary of Abraham Lincoln's birth. Though no one suspected it at the time, Pippin would forge an artistic relationship with the slain president and later devote part of his energies to an artistic envisioning of Civil War history. Though West Chester was the site of his birth, he wouldn't yet call it his home.

"My mother left West Chester when I was very young," Pippin later wrote. "And my first knowledge of anything was in Goshen New York."[1] Located in southern New York State, in the lower Catskill Mountains, Goshen was a charming town of about five thousand people, but it

was also a place that time had forgotten. While many Goshen residents had picked up and moved west since the construction of the Erie Canal, those that remained lived in something of a time warp. The technology they used to run, or power, their lives was quite similar to what it had been a century earlier, and Horace grew up in the quiet and calm of a late-nineteenth-century small town.

"When I was seven I began to get into trouble," Pippin declared.[2] Attending the one-room schoolhouse on Merry Green Hill, he showed a predilection for the arts from an early age. When vocabulary words were presented on the board, Horace laboriously copied them, but he also drew a sketch of the object—an apple, a spade, or a dog, for example—right at the end of his written copy. Whether the teacher was irritated or amused is not certain, but Horace was kept after school on many occasions so he could redo his writing assignments. "The worst part of it," Pippin recalled, "was I would get a beating when I got home, for coming home late, regardless what I were kept in for."[3] Today we would very likely call this child abuse, but no trace of self-pity or anger emerges in Pippin's writing. He grew up at a time when parents' decisions were practically law, as far as their children were concerned.

In "My Life's Story," an appendix to a book of one of his works, Pippin does not declare who administered the beating. It seems very likely, however, that it was either his mother or grandmother. Pippin knew almost nothing about his father, and the maternal presence in the Pippin household was very strong. This later became evident when Pippin painted scenes from early life in which strong female figures nearly always dominate.

To the best of public knowledge, Horace Pippin had no suitable painting materials in his youth. He won a prize for sending a "funny face" to a Chicago magazine, however, and he soon received crayon pencils of six different colors. These he used to make drawings for his Sunday school class, and, much to his surprise, a local woman purchased them. At about the age of ten, Horace had achieved his first sale. "I took the good news to my mother, who was delighted,"[4] he wrote.

A Dream Deferred

While his mother worked as a domestic servant in the nearby town of Middletown, Horace went to work on a local farm. He declared that the work was not very tiring and that he and the other field hands had plenty of time to themselves in the evening. On one of those occasions, Mr. James Gavin—owner of the farm—fell asleep while reading his newspaper. On awakening, Gavin found a pencil sketch of himself and was astonished at the quality of the drawing. When Horace revealed that he made the sketch, Gavin announced his intention to send the boy to art school.

But the promise of this exciting opportunity collapsed when Horace's mother became ill. The nature of her illness is not known. She had lived a tough life, however, performing hard work from an early age, and she may have been simply worn out. His painting *Christmas Morning Breakfast* shows her importance in his life. She spent her last years at the Old Mill House, which forms the center of one of Pippin's later paintings. Whether Pippin had siblings or half-siblings is not well established, but the tone

10 HORACE PIPPIN: Painter and Decorated Soldier

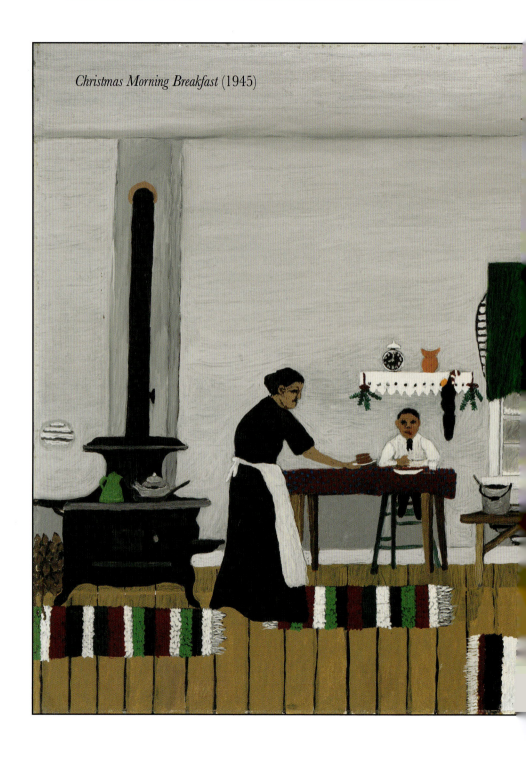

Christmas Morning Breakfast (1945)

The Youth of an Artist

of "My Life's Story" presents a powerful sense of aloneness. One can easily guess that Pippin believed he had to be the "man of the family" from an early age and felt a strong sense of responsibility for his mother's care.

"I am now fifteen years old, and my first job was unloading coal at the coal yard,"[5] Pippin wrote. By fifteen, he had already developed a large, strong physique, and there is little doubt that the hard labor made him even stronger. The habit of hard work developed early in Horace, and throughout life, he seldom, if ever, shirked a difficult duty. One can, of course, say that the same was true of thousands—if not tens of thousands—of other black youths. In Horace's case, however,

Teenage Rebellion?

No sense of teenage rebellion or resentment comes from Pippin's autobiography. He grew up in a time when care of the elderly was mostly done in the home. His mother, too, had provided nearly all the stability he had ever known. Pippin, therefore, carried on with his double task—that of earning a living and caring for a parent.

physical strength would be joined to a powerful will *and* an innate artistic talent.

"I went from the coal yard to a feed store,"[6] Pippin declared, and from there to other jobs involving manual labor. Looking for something different, he applied to and was hired as a porter at the St. Elmo Hotel. His friends teased him, saying he would not last three weeks, but Horace remained there for seven years. It was during this period that his mother died.

His world was shattered.

On His Own

Most of the themes Pippin later painted derived from the concept of "home." Very likely, this is because his own home was taken away at about the age of eighteen. Perhaps he could have remained in Goshen, living with relatives, but Pippin felt the need to strike out on his own. He moved to Paterson, New Jersey, and worked for the Fidelity Storage House.

The Youth of an Artist

Beyond these basic biographical facts, details about Pippin's domestic and romantic life are almost completely lacking. A sense of bleakness entered his life at the time of his mother's death, and it seems like Pippin was just marking time. Though the advent of the First World War would bring him misfortune, Pippin's first response was one of joy. He had an opportunity to do something quite different and perhaps escape from the limiting confines of his youth and adolescence.

Pippin enlisted in the New York Fifteenth, an all-black regiment recruited in and around New York City. His life would never be the same.

Chapter 2

Life as a Black Soldier

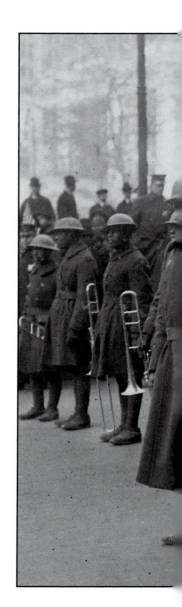

Though war broke out in Europe in August 1914, the United States initially took a position of neutrality in World War I. It wasn't until April 1917, after Germany used aggressive naval tactics that harmed US merchant ships, that America entered the war. Joining the ranks of the Allies, America opposed the Central Powers, composed of Germany, Austria-Hungary, Turkey, and Bulgaria. War had never been waged on such a massive scale, and the demand for soldiers would sweep Horace Pippin into a series of events that would alter the course of his life.

The New York Fifteenth

When President Woodrow Wilson led the nation into war, America's army of 130,000 was composed entirely of

Life as a Black Soldier 15

volunteers. President Wilson hoped this could remain the case, but the need for manpower was so great that the nation saw its first draft, otherwise known as military conscription, since the Civil War. In Horace Pippin's case, the change made no difference. He had already enlisted.

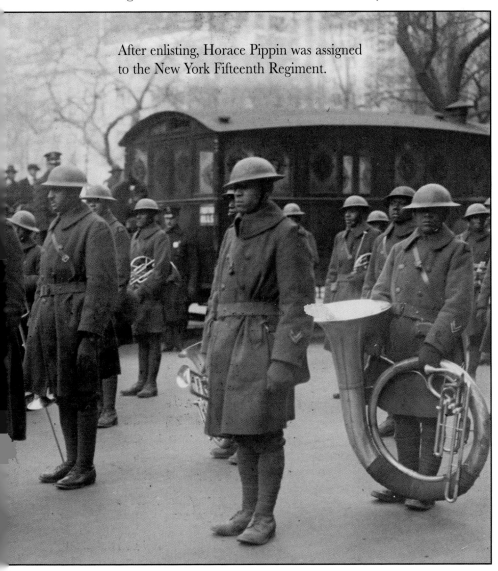

After enlisting, Horace Pippin was assigned to the New York Fifteenth Regiment.

16 HORACE PIPPIN: Painter and Decorated Soldier

Pippin's draft card has survived an entire century. Reproduced in *Suffering and Sunset: World War I in the Art and Life of Horace Pippin*, the draft card indicates that at this early stage of life, Horace Pippin preferred to use the pronunciation "Harris" for his first name. The draft card shows that Pippin enlisted on July 15, 1917, and that he listed C. Green, a sister, as his closest living relative.[1]

Pippin, very likely, was pleased to put on the uniform of "Uncle Sam." He did not realize the sacrifices he would be called upon to perform or the fame that would come to him as a member of one of America's most famous regiments.

The New York Fifteenth started out as part of the US National Guard. All the enlisted men were African American, and nearly all the officers were white. Colonel William Hayward, the commanding officer, was a well-educated man who hailed from Nebraska but had moved east to New York around 1911. As a member of the Union League Club of New York, a prestigious social club that had sponsored several military units of African American soldiers during the Civil War, Hayward approved of recruiting and leading black soldiers in the war effort. Though Hayward would eventually bond with his men and become one of their staunchest advocates, the soldiers of the New York Fifteenth knew they had to prove something: They needed to demonstrate that they were as good as white soldiers. But not everyone was rooting for them.

Basic Training

The New York Fifteenth headed south by rail, arriving at Camp Wadsworth in Spartanburg, South Carolina. If they thought they would receive a good welcome, the

African American soldiers were soon persuaded otherwise. Even before the first men arrived, the white mayor of Spartanburg declared, in a local newspaper, "I can say right here they will not be treated as anything except Negroes."[2] In other words, it made no difference that these men wore the uniforms and carried the colors of the United States—they would be treated as second-class, if not third-class, citizens in their own land.

The mayor's statement was all too accurate. The owners of restaurants and bars refused to serve the men of the New York Fifteenth. There were dustups in local bars and hotels, one of them involving one of the most famous of all African Americans of World War I: James Reese Europe, the celebrated ragtime and jazz bandleader. After a hotel owner launched a racially motivated attack on a black soldier, Europe kept the peace among his fellow

James Reese Europe

Born in Alabama, James Reese Europe was eight years older than Horace Pippin. Unlike Pippin, Europe's natural gift—for music—was celebrated and encouraged at an early age. He became the number one composer and organizer of black popular music in the years prior to World War I. During the war, Europe served double duty, as bandmaster of the regiment and commander of a machine-gun company. Tragically, Europe was killed by a fellow band member in 1919, one year after the war ended.

soldiers—white and black—who were furious over the assault. Military police took the regiment back to base.

But the damage had been done: it was clear that the local white community in Spartanburg would not accept these black soldiers. Basic training for the New York Fifteenth was cut short, lasting just twelve days. The Fifteenth traveled again by rail, reaching Hoboken, New Jersey, where they boarded the USS *Pocahontas*, headed for the battlefields of the Western Front.

Meeting Setbacks with Spirit

The equipment provided to African American soldiers was often inferior, or substandard, and transportation was no exception to the rule. The USS *Pocahontas* was in such bad shape that she made three tentative ventures into the Atlantic, returning each time for refitting and repairs. Only on the fourth attempt did she finally get into the deep water and across the Atlantic. Pippin and his fellows landed at the port of Brest, in the French province of Brittany, shortly after Christmas of 1917.

Having grown up in New York State, Pippin expected to be able to handle the cold weather. He and his fellows found it much worse than expected, however, and they endured a long train ride south, to the French town of Saint-Nazaire. The men of the Fifteenth longed to be sent to the front, to prove their worth, but they spent nearly three months repairing a damaged French railroad line.

During this time of hard labor, Pippin began drawing, and the sketches that survive indicate the development of his native talent. Not all of the pictures survive, but those that do display poignant scenes, such as African American

soldiers marching by the light of the stars. Whether Pippin believed these drawings would one day testify to the valor of black soldiers is unknown; but given our vantage point, it is clear that he and his fellows in the Fifteenth were as rough and ready as men can be. Finally, in the spring of 1918, the Fifteenth was sent to the front.

Service with France

Most white American officers—from captain up to general—did not wish to deploy black troops in the field: they much preferred using them as workhorses, behind the lines. But when Imperial Germany started a series of offensives in March 1918, the US Army had no alternative.

Trench Warfare

Between 1914 and 1918, fighting on the Western Front was characterized by what we call trench warfare. Opposing armies dug enormous trenches on both sides of the battlefield, and a 600-yard (548-meter) area in between was labeled "No-Man's-Land." The fighting men on both sides dreaded the words "over the top," which meant they were to exit their trenches and charge across the land in between with no cover or protection. Horace Pippin and his fellows of the 369th had one advantage. Though trench warfare was still a well-used method, they arrived at the front just as trench warfare was beginning to yield to a more flexible and fluid style.

HORACE PIPPIN: Painter and Decorated Soldier

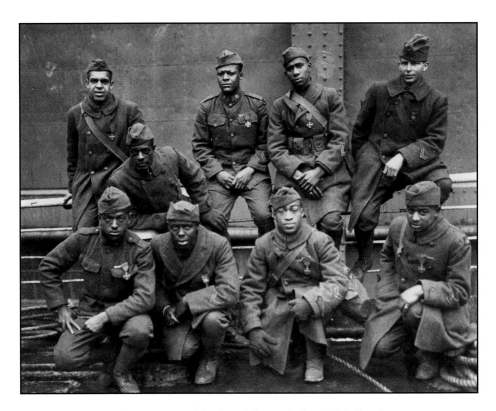

Even though the young black soldiers of the 369th Regiment were risking their lives for the United States, they still faced discrimination and unequal treatment within the army.

The New York Fifteenth was redesignated the US 369th Regiment and sent to the front. Even then, however, the black soldiers were not given their complete due. Rather than serve alongside their white comrades, the men of the 369th were detailed to join the French Fourth Army. The black soldiers had their baptism by fire in the Champagne Sector of the Allied lines.

Pippin and the other men did not mind serving with the French. The food was better, and the French were more

willing to treat these young black men as equals. French weaponry, however, was another matter: the US soldiers were convinced that American equipment was superior. The Lebel rifles used by the French were especially tricky to load, leading them to rely much more on hand grenades in combat. But the camaraderie with French soldiers more than made up for these challenges, as each soldier in the 369th Regiment was paired up with a French soldier to train and learn about the tactics of warfare. The American and French servicemen bonded in the trenches, strategizing about the way forward.

As part of the French Fourth Army, the men of the 369th fought on the defensive. Throughout the spring and summer of 1918, they helped repel the toughest and most severe of all German offensives. The German high command threw all of its best units into these attacks, but ultimately they failed. As summer turned to autumn, the men of the 369th prepared to go on the attack.

Chapter 3

The Most Traumatic Day

The single most important—and most traumatic—day of Horace Pippin's life took place at the end of September 1918. Though the exact date is unknown (it is presumed to be either September 29 or 30), the events of that dark autumn day would be a memorable and critical part of Horace Pippin's work, both in his art and his letters. The horror of war changes people, and that was certainly true for Pippin, who was shaken to his core.

Under Enemy Fire

Pippin was no stranger to combat. He had risen to corporal during the long campaign and had led

The Most Traumatic Day

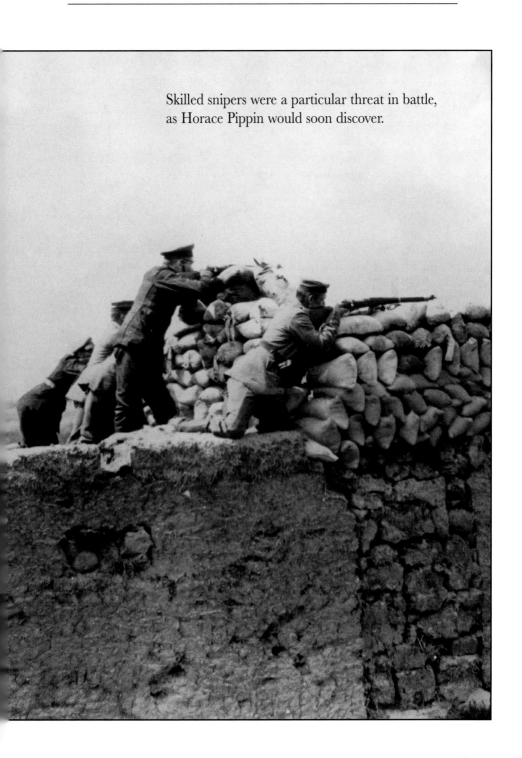

Skilled snipers were a particular threat in battle, as Horace Pippin would soon discover.

his platoon into danger several times. But as the 369th Regiment went from defense to offense, and as the French Fourth Army pushed the Germans back, the fighting became ever more intense. The German army was renowned for this defensive skill and its ability to inflict more casualties than it suffered, even when in desperate circumstances.

"The German lines were strong," Pippin wrote. And shells [were] dropping everywhere. Yet we were advancing slowly."[1] Pippin had run out of rations and had barely eaten anything in forty-eight hours. Yet he, along with the other men of Company K, was engaged in deadly conflict.

"The snipers were thick also, I seen a machine gun nest I got him,"[2] Pippin wrote. Pippin and a fellow soldier saw another German sniper, who was holding up the American advance. Pippin and his friend exited the shell hole at the same time and planned to enter the German's shell hole from opposite ends. The men of Company K had executed moves like this on numerous occasions and had become very skillful at the maneuver. But things could always go wrong.

Pippin and his buddy—who went unnamed—did not realize that the German sniper was behind a large rock. They entered the shell hole at the same moment, searching for their foe, but Pippin was exposed at just the wrong moment. "He let me have it. I went down in the shell hole. He clipped my neck and got me through my shoulder and right arm."[3] The men of Company K may have escaped fire many times, but this time it was their turn to feel the fickle hand of fate.

The Most Traumatic Day

Lying in the shell hole, with blood oozing from his right arm and shoulder, Pippin was tended to by his comrade, who wrapped his wounds. There was no time to dress the wounds or to guard against infection—the fight wasn't over. The two men shook hands, and Pippin's buddy departed to seek out more Germans. Pippin never saw him again.

Pippin's wounds were serious. But the trauma, partly inflicted by uncertainty, was even worse.

Shell Holes

It's no surprise that the palette of *Shell Holes and Observation Balloon* is dominated by grim gray, a sense of unease hanging over the work. Working from memory, Pippin painted a French farmhouse in disrepair and two enormous shell holes. The holes are so carefully done that they resemble

Shell Shock

Today we call it post-traumatic stress disorder, or PTSD. During World War I, it was known as "shell shock." In either case, the mental anguish and trauma experienced by soldiers—on both sides of the conflict—required a name, a description around which doctors and psychologists could frame their treatment. And in World War I, it made excellent sense to label it "shell shock." The shock caused by enormous projectiles hitting buildings and creating gaps in the earth was sufficient to send many soldiers to the military hospital.

26 HORACE PIPPIN: Painter and Decorated Soldier

irises, and the top of the holes look like flowers ready to open. This was Pippin using artistic license, however; in reality, those holes were hardly so poetic—they were craters created by massive artillery shells, fired during some of the heaviest bombardments of World War I.

The observation balloon is in the background. An observer would not give it any special notice except that it appears in the title. Gazing at it, the viewer realizes that Pippin is using the balloon. The circumstances on the ground—the ones he faced in 1918—were so grim, indeed horrific, that he needed an "overview" to handle the trauma.

But no illustration can fully capture what happened to Pippin on that fateful day or how it would come to affect him for years afterward.

Waiting for Rescue

Pippin received his wounds around 8 a.m., and he lay in the shell hole, completely alone, until 2 or 3 p.m. For hours, he remained injured and helpless, listening to gun, rifle,

The Most Traumatic Day 27

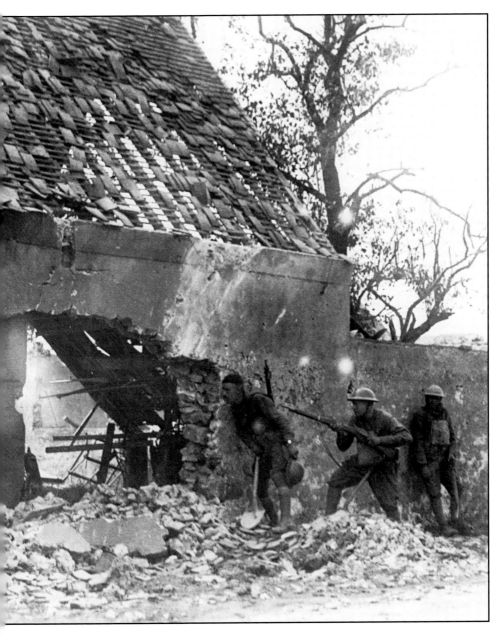

Artillery bombardments destroyed many parts of Europe during World War I. Horace Pippin was all too familiar with this kind of house-to-house fighting.

and machine-gun fire, but he could not see anything. Each passing hour found him weaker than the one before.

A group of French "swipers" came by: these men had the task of "swiping" out the remaining German enemies. One of them approached Pippin. "He stopped to say something to me," Pippin wrote. "But he never got it out for just then a bullet passed through his head. And he sank on me. I seen him coming on but I could not move."[4] Weak from the loss of blood, Pippin could not move the body of that dead Frenchman, who lay on top of him for the next six or seven hours.

Precisely what went through Pippin's head during those hours will never be known. Like many strong, self-made people, Pippin was not very good at expressing his emotions in words. Later, he would put pen and ink—as well as paint and brush—to work, but he would never be able to put those terrible hours in words. He was far from alone in that regard.

"Two boys came and I woke up," Pippin wrote. "They took the French man off of me, and then took me out of the shell hole for some distance where there were more wounded ones. I was left there the rest of the night."[5] To us, removed from a distance of more than a century, the treatment seems terrible. We are accustomed to medical groups and care being available at all times. It was not so for the soldiers—dark and white—of the First World War.

Everything Goes Dark

Pippin did remember being carried out on a stretcher. He remembered the artillery shells bursting in the air, and he remembered the fear that he would roll off the stretcher.

Pippin's Comrades

One of the greatest military historians, John Keegan, wrote eloquently about the simple fact that soldiers fight primarily for each other. Governments, nations, and competing beliefs may start wars, but the only thing that keeps the common soldier engaged is the affection he feels for his friends. In Pippin's case, the battle toll was severe. More than 600 of his comrades died in France, and another 1,200 were wounded.

But most of his world was going black, right in front of his eyes.

Thousands, even millions, of other men had similar experiences in the First World War. British, French, Russian, and German soldiers were wounded in great number, and they suffered just as much as Pippin in those moments. But Pippin had something very special to offer. Not only did he write about this terrible experience, he also later painted his way *through* the trauma he endured.

On arriving at the hospital after hours of lying injured and alone, it was all Pippin could do to name his rank, serial number, and regiment. He hoped that the French medical officers would be able to fix what was wrong. In truth, however, his right arm and shoulder would never be the same again.

Chapter 4

A Painful Return

The 369th US Regiment won everlasting fame during World War I. Awed by their strength and resilience under fire, German opponents labelled the black soldiers "hell fighters." The name stuck: the servicemen of the 369th became known as the Harlem Hellfighters.

The regiment made a triumphant return to the United States in the winter of 1918–1919. Many surviving soldiers participated in a grand parade in New York City, the first ever offered to an all-black regiment. But for every African American soldier that returned, there was another who was killed or who returned wounded. One of the latter was Horace Pippin.

A Bittersweet Homecoming

Pippin came home from the war with a mangled right arm and shoulder. He was listed as a 90 percent disability case and awarded a small pension, which later paid $22.50 per month. He was justly proud of what he accomplished in World War I but also despondent over the future. Throughout life, he had made it, sometimes just barely,

A Painful Return

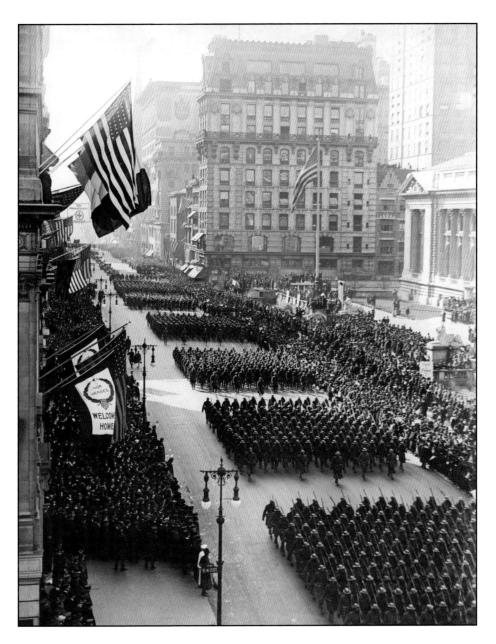

The Harlem Hellfighters returned to a heroes' welcome in New York City.

through the strength of his arms. He had shoveled coal, packed furniture, and carried luggage. None of this was now possible.

Pippin did, however, find a partner to aid him in his emotional postwar recovery; Jennie Wade was twice widowed with an eight-year-old son from a previous marriage. Though not much is known about Wade or her courtship with Pippin, she worked as a domestic servant, much like Pippin's own mother. In 1920, the couple married.

Pippin could have returned to New Jersey, where he worked as an iron molder before the war. He could have returned to Goshen, New York, where, presumably, his sister and perhaps some cousins lived. But he chose to return to his oldest roots, settling his new family in his birthplace in West Chester, Pennsylvania. It was here that Pippin would attempt to make sense of his new life, now forever altered by his military service.

Seeking Answers

Pippin's disability bothered him. That his wife supplied many of their material needs, by working as a laundress, distressed him. But the single biggest cause of Pippin's discontent and sadness was his inability to cope with the terrible wounds—psychological as well as physical—of World War I.

It's not difficult to see why Pippin would have found comfort in a renewed sense of religious belief. He attended Sunday school during his days in Goshen, New York, so there is good reason to believe that he was raised with a strong sense of the Bible. But it's also very likely that the

trauma of World War I served to deepen his sense of religion and made him more dependent on God than before. During the war, he prayed for deliverance from his service: "I did not care what or where I went. I asked God to help me, and he did so. And that is the way I came through that terrible and Hellish place. For the whole entire battlefield was hell, so it was no place for any human being to be."[1]

Religion helped Pippin understand where humans went wrong and why they engaged in war unjustly—as was the case with the First World War. But it did not take him all the way: he still had to find a way to wrestle with his own particular experience. Had he come home in perfect health with full mobility and use of his body, Pippin would likely

Pippin's Notebooks

Sometime between 1920 and 1922, Pippin made several attempts to write down everything possible about his World War I experience. The result is the Horace Pippin notebooks, preserved at the Smithsonian Institution and made available for viewing online. Many other World War I soldiers recorded their experiences, but few made so many attempts and, even more exceptionally, Pippin was one of only a handful of African Americans to leave written commentary. His words show the war from a black viewpoint. Later, he'd do just the same with his paintings.

have turned to painting much sooner. Given that his right arm was close to useless, he initially decided to write his way through his postwar suffering.

Writing His Way Out

"I remember the day very well that we left the good old U.S.A. although she were in trouble with Germany," Pippin wrote. "To do our duty to her, we had to go and leave her."[2] That Pippin describes his nation in the feminine was not unusual; many soldiers did so. But given that he had been devastated by the loss of his mother a decade earlier, the words "we had to go and leave her" take on an especially potent meaning. Fear and loss weighed heavily on Pippin, and leaving the motherland of America behind would be just one of many difficulties he would detail in his journals.

Pippin described the terrible, cold weather he and his fellows experienced on arriving in France in December 1917 before pivoting to his experiences on the battlefront. "The fog was so thick that you could not see out side of a 100 feet away, well the artillery fire raised and we went over the top once more we fought on that morning and gained the hill, that afternoon we got in a cross fire of machine gun fire."[3] Pippin describes losing most of the men of his platoon in that machine-gun fire, but he went even further when describing the death of one particular black soldier.

"A boy in the outfit looked weary and funny, some time he looked like he was scared through," Pippin wrote. Pippin asked the young man what was wrong, and he replied that he knew he would not return from the attack they were about to make. Pippin consoled the man, saying this was a volunteer mission, and he did not have to participate. He

Folly and Destruction

Horace Pippin was just one of the many soldiers who endured the folly and destruction of the First World War. Men of all the nations involved, including Germans and other soldiers fighting for the Central Powers, wrote poignant words about the stupidity of trench warfare and the endless number of lives that were lost. During rainstorms, the trenches would flood, filling soldiers' boots with muddy water, often causing a fungal infection known as trench foot that could lead to amputation. Lice and rats clustered in the trenches, spreading disease and death. Even those men who didn't die in combat faced significant health hazards just by being in the trenches.

replied that he was going forward, in the full knowledge that he would never come back. "Five minutes later we were back in our trenches again with two German prisoners,"[4] Pippin wrote. And the young man he had spoken to was, indeed, dead in No-Man's-Land.

The Turn Toward Art

Pippin had been away from visual art for a very long time. He had sketched and painted while in France, but since then the wounds to his right arm and shoulder had made it impossible. While the precise date is unknown, sometime in

36 HORACE PIPPIN: Painter and Decorated Soldier

Asleep (1943)

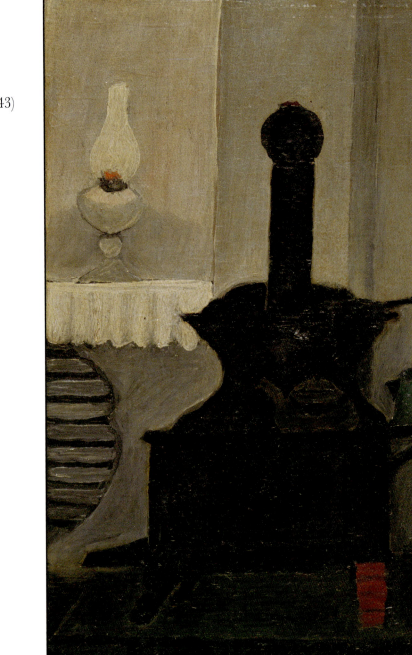

A Painful Return 37

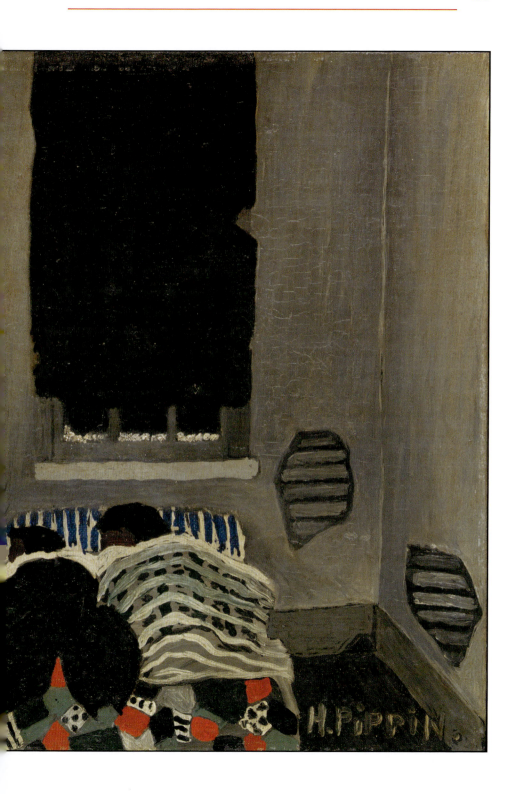

the late 1920s, after nearly a decade of trying to adjust to civilian life, Pippin began to make art again.

The weariness of this time endured throughout his career, as even his later work exhibits. In one painting is a gloomy scene, with the action taking place in a home at night. Two African American boys lie on a bed, with their heads pointed away from the viewer. Somehow, Pippin conveys to the viewer that it is the dead of winter, and the sun has just gone down. The title is short, *Asleep*, but eloquent, a testimony to what Pippin—and many other African Americans—experienced in the aftermath of the First World War.

Chapter 5

Painting the War

Visual artists often work in spurts, meaning that they use all the inspiration they have for a particular project, take a good rest, and then return to more of the same. Horace Pippin was different in this regard; once he returned to visual art, he painted steadily, cultivating a sustained state of creativity.

Exactly when he painted remains a subject of dispute. Was he an all-night worker, toiling by the light of one 200-watt bulb? Or did he take advantage of the abundant sunlight in his area of suburban Pennsylvania? What we can say, with certainty, is that Pippin approached his art with a workman-like dedication—he kept at it, day after day and year after year.

His first great subject was the one that still pained him down deep: the scars remaning from his experience in World War I.

Starting Home

Home was one of the central aspects to all of Horace Pippin's art. Time and again, he painted or sketched scenes of "home," whether that meant Goshen, New York,

40 HORACE PIPPIN: Painter and Decorated Soldier

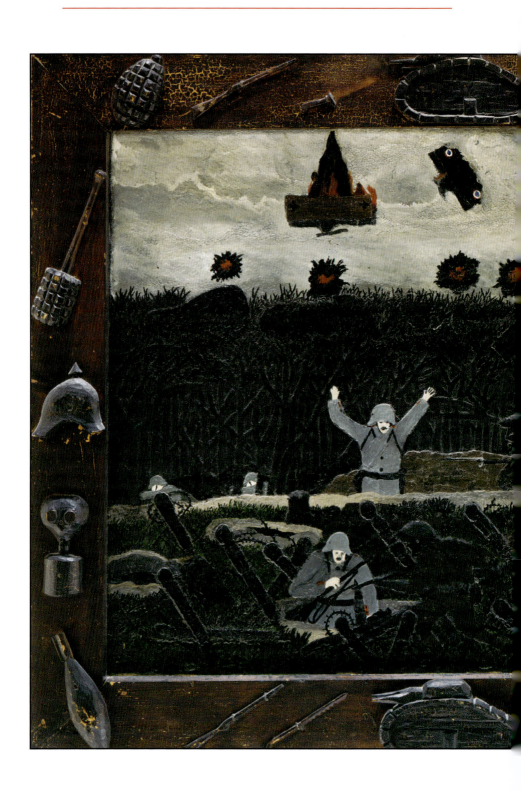

Painting the War 41

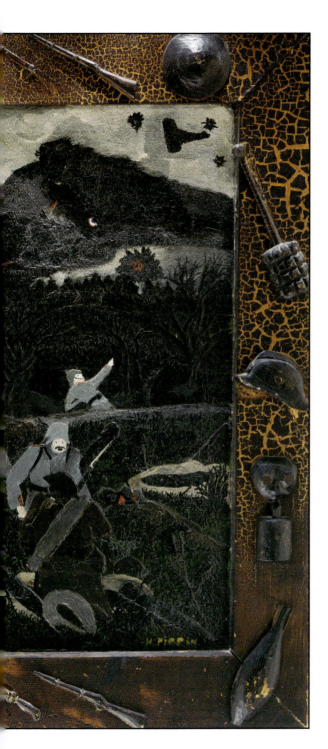

The End of the War: Starting Home (1930–33) has a hellish quality, but it launched Pippin's artistic career.

or West Chester, Pennsylvania. But in his largest canvas, Pippin concentrated on the concept of "starting home." He painted the torment of battle and the end of World War I, from his perspective as a soldier.

Pippin later claimed he used one hundred layers, or coats, of paint on the masterpiece entitled *The End of the War: Starting Home*. He did not restrict his paint to the inner section of the canvas, painting and decorating the outer edge, perhaps as a statement that his vision—on this subject—could not be contained. Many other soldiers—British, French, German, and American—were as affected by the war as Pippin. Rather few of them possessed his innate quality for portraying the event, however.

The End of the War is a grim but also fascinating depiction of modern war. The landscape is painted in a dark army green that appears almost black, but small dots of red show where blood has flowed and sacrifices have been made. The sky is a sickly greenish-blue, with splashes of red indicating artillery shell explosions and the destruction of at least one war plane. The viewer's eye is drawn to the outside of the canvas, where Pippin has painted—almost plastered—a helmet, a tank, numerous rifles, as well as helmets. All the apparatus of modern war appears on this outer edge.

The viewer is then pulled to the center of the painting. Several German soldiers, clearly identified by their distinctive *Stahlhelm*, or steel helmets, are shown. One has his hands up in a broad demonstration of surrender, two others still clutch their rifles, and yet another is in the act of falling dead (given his own battle wounds in France, it is likely that Pippin identified with this soldier). Two other Germans are in the act of sneaking away.

Tanks and Planes

Did Pippin see tanks in action? Very likely so, or else he would not have chosen to paint two of them on the outer edge of *The End of the War: Starting Home*. These are distinctly World War I tanks, cumbersome and slow, but their presence manages to convey the even greater damage—and horror—that would happen in World War II. The aircraft in Pippin's painting are, likewise, of World War I vintage. Pippin never claimed prophetic powers, but his artwork points both to the carnage of World War I and foreshadows that of World War II.

Three American soldiers—all of them African American—are taking over the battlefield at center-front. The black men are shown as distinctly larger and more powerful than the Germans, and there is the look of an avenging angel, or perhaps a hunter, to them. Even while the war remains his primary focus, it was clearly important to Pippin to highlight the critical role of black soldiers in the winning of the First World War.

One searches in vain for light, charity, or hope. *The End of the War: Starting Home* is a severe reminder of the terrors of war and its ability to dehumanize the best of men. Yet this painting served as the launching pad for Pippin's artistic career. Several people—all of them middle- or upper-class white Americans—later claimed to have "discovered" Pippin the artist. In truth, he made, or forged,

44 HORACE PIPPIN: Painter and Decorated Soldier

his own artistic identity and did so primarily through this one painting, which opened the door to all the others.

Scenes of War

Pippin was not finished with war—not by a long shot. He spent much of his artistic energy in the early 1930s in turning out other depictions of the terrors he had witnessed. One suspects that these paintings constituted a form of therapy for Pippin. One also wonders if he would have made it or adjusted to civilian life without creating them.

Outpost Raid: Champagne Sector was painted in 1931, and it forms the second part of Pippin's military paintings. He had already rendered the intense horror of war in general in *The End of the War: Starting Home*, and he could now depict specific scenes from his experience. An African American soldier, whose face is not shown, enters a German trench: the viewer can see the wooden steps that lead from the upper ground to the depth of the trench. The raid is conducted in wintertime, and the

Painting the War 45

Outpost Raid: Champagne Sector (1931)

snow provides an inversion of the darkness of the trench. The black soldier has his rifle and attached bayonet raised, while the German defender turns with a snarl. Does the German hold a pistol in his concealed right hand? The viewer is left to guess.

What is not open to question is the outcome. No matter how hard and well the Germans fight, they cannot stem the tide of these black soldiers, who seem quietly invincible. Pippin conveys this sense through bodily posture and positioning. No matter how difficult the fight, the American soldiers will prevail.

Pippin saved his best for last. In 1945, fifteen years after *The End of the War: Starting Home*, Pippin painted *The Barracks*. The scene is Allied military quarters, somewhere in Europe during the First World War. Two separate groups of bunk beds, each three levels high,

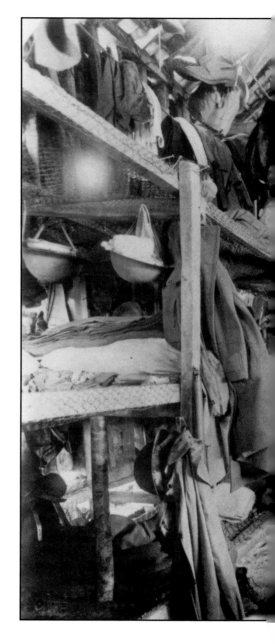

Painting the War 47

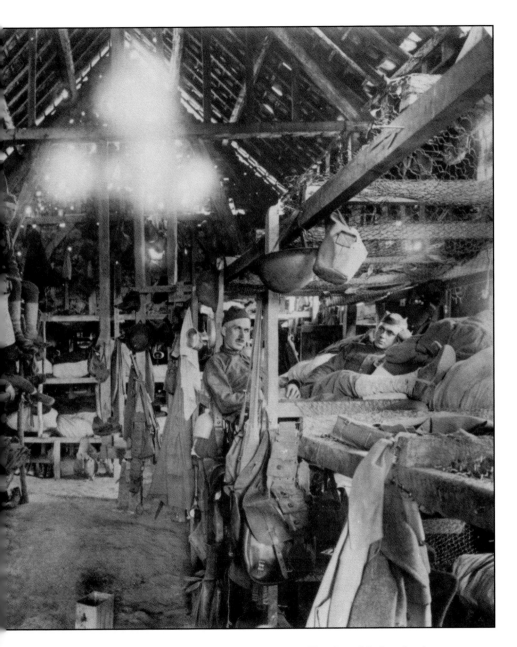

The World War I barracks provided Pippin with inspiration for his art.

HORACE PIPPIN: Painter and Decorated Soldier

Pippin as Folk Art Master

Because he was African American and because he had no art school experience, Pippin was often treated with condescension by the art world. Some white art specialists simply refused to believe that a black person of limited education could possess such skill and reach such creative heights. But in his depictions of the First World War, Pippin moved from self-taught apprentice to master. One can think of more elegant or delicately rendered art concerned with modern war, but it is impossible to think of any that is more poignant. Having experienced the Great War, Pippin put those experiences on canvas to deep and moving effect.

dominate the painting, which shows four soldiers. One sleeps and another appears to be reading, while two others are in the act of clothing themselves. Expressive even in its simplicity, *Barracks* conveys the profound loneliness of modern soldiers and maybe even of modern humans in general. They are together, yet separate, each having his own private experience.

But perhaps there's a sense of poetic redemption in Pippin's decision to turn these painful, isolating experiences into art. By putting brush to canvas, one hopes that, in some small measure, Pippin let go of the trauma he encountered as a soldier and built a bridge to connect with those who had experienced the same sadness and isolation.

Chapter 6

An Evolving Style

It is difficult enough for a person to manifest and direct his or her art. In Pippin's case, this took more than a decade, the start of his artistic career blooming with his paintings of World War I. But the artist often has a second, very demanding concern—he or she needs to be noticed by the art world. In Pippin's case, this was already happening in his local community. Nonetheless, to reach a broader audience, Pippin had to broaden his appeal.

Scenes of Nature

While Pippin began to transition from burnt-wood work to oil paintings, he continued to experiment with both types. Having worked on a major war scene, he now turned his hand, and brush, to nature.

In 1930, Pippin painted one of his major works. In *Losing the Way*, he clearly establishes himself as a narrative painter, one who uses scenery to tell the story of a country doctor attempting to reach an ailing patient. He signs the painting in the lower right corner, and having made this

50 HORACE PIPPIN: Painter and Decorated Soldier

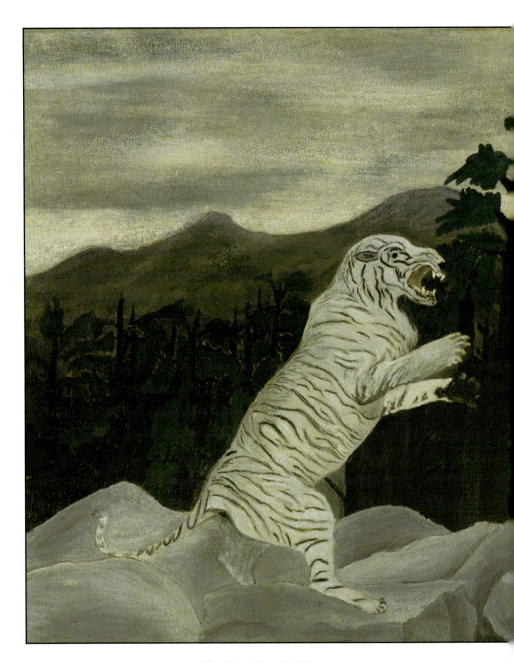

The Blue Tiger (1933)

An Evolving Style 51

adjustment, he will never look back. All subsequent Pippins are signed at bottom right.

The Blue Tiger shows a massive bear, somewhere between a brown bear and a grizzly in size, locked in battle with a tiger against a snowy landscape, the brutality of nature on full view.

Hunter and Prey

Pippin seldom spent time outside his native regions of New York and Pennsylvania. But he employed his imagination to depict far-off scenes. One of the best of these is *Cabin in the Cotton*. Pippin shows a rustic cabin, painted at roughly the time of sunset. There is impending darkness and a sense of poverty as well as loss, but one also senses the determination and industriousness of the African Americans placed in front of the cabin. They have survived another day and lived to tell the tale.

An Evolving Style

Pippin and Lincoln

Born in 1888, Pippin came into the world only twenty-three years after the end of slavery in the United States. Sharing the same birthday with Abraham Lincoln, Pippin identified deeply with the fallen president. It is not surprising, therefore, that he was moved to paint Lincoln.

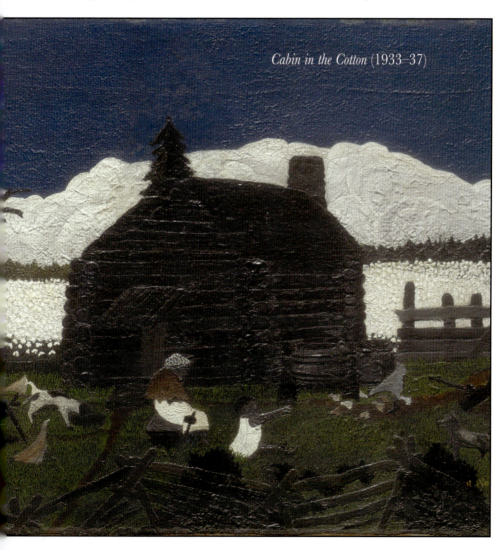

Cabin in the Cotton (1933–37)

54 HORACE PIPPIN: Painter and Decorated Soldier

Abraham Lincoln and His Father Building Their Cabin on Pigeon Creek (1934)

An Evolving Style 55

What *is* surprising—and what suggests that Pippin had a long-range view—is that he painted the American president as a teenager, rather than a powerful man.

In 1934, Pippin finished *Abraham Lincoln and His Father Building Their Cabin on Pigeon Creek*. Father and son are depicted in the center foreground. Their heads are turned away from each other as they swing their axes, fashioning beams for their log cabin. The home is about one-third complete, and the men must work hard to make sure it is ready in time for winter. Speed is clearly shown, as is strength: this is young Abe Lincoln, the person of whom so many stories and myths would later be spun. Perhaps Pippin knew that Lincoln had a difficult, even painful, relationship with his father, Thomas. At the same time, Pippin knew quite clearly that Lincoln was fortunate to *have* a father—he himself did not.

The cabin and the men with their axes naturally claim most of our attention, but the viewer's eye then drifts to the far left, where an immense number of stumps indicate

Artist Signatures

The concept of the artist as an individual, one who leaves his mark on the work, dates back to the Italian Renaissance: most paintings from the Middle Ages are unsigned. One can tell a "Pippin," meaning a painting executed by Horace Pippin, both by observing the color palette and by the artist's distinctive signature. While he sometimes used cursive in the writing of letters, Pippin always signed his works with printed capitals.

The Father Figure

With his mother as his sole caregiver for his early life, it is no surprise that Pippin developed a sense of comfort in the company of women. The lack of a father in his home made this almost a certainty. But when he did depict male figures, Pippin gave them almost supernatural strength. Soldiers, hunters, healers—these men had clear, valuable power in society. While it's impossible to know for certain, it's very likely that Pippin missed the presence of a father and idealized the importance of a father figure in one's life.

the work already performed. This is no small venture, the building of a home, and Pippin's work suggests that many sacrifices have already been made.

By the end of 1934, Pippin had become a true painter—one who uses oil on canvas to tell stories and raise questions. His development since the year 1930 was striking. But he was almost completely unknown. And this, naturally, raises yet another question: Had Pippin never been discovered, would he have continued making art? Often in matters like this, the viewer must be careful to hedge his bets. But to this question there is one sure answer. When questioned about how he chose subjects for his art, Pippin famously replied, "Pictures just come to my mind, and I tell my heart to go ahead."[1] With such creative drive, there's no doubt that Pippin would have kept on, regardless of whether the world knew of his efforts.

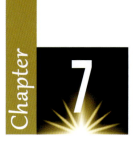

Road to Discovery

Every artist wishes to be discovered. He knows he cannot simply call attention to his art all on his own; the power and beauty of the work must speak for itself, summoning interest from other people. Many fine, even great, artists never get discovered—their works remain unknown to the public. Fortunately, this did not happen in Pippin's case. He was lucky in that the Pennsylvania suburbs had more than the average number of people who loved, or were interested in, art. His local community recognized the diamond in the rough.

Beginnings in West Chester

For the first fifteen years that Pippin, his wife, and his stepson were settled in West Chester, Pennsylvania, their lives did not change much at all. Jennie Pippin took in laundry to supplement her husband's meager disability payment. Pippin sometimes helped his wife with the laundry. At other times, he worked as a "junk" man, collecting and selling

Road to Discovery 59

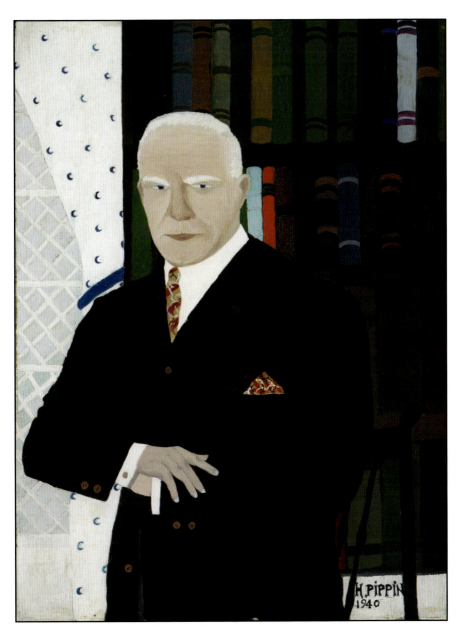

A Chester County Art Critic (1940)

household items. Throughout this time, he painted. But as yet, there was no income from his art.

Perhaps around the year 1935, Pippin began to advertise his paintings. He sometimes offered them to West Chester merchants, in substitution of payment. Some of these merchants agreed to hang other pictures in their shops.

Artist and Art Critic

It is almost impossible to nail down the date when Pippin first was discovered. In fact, there are many different tales about Pippin's first public recognition and how it happened. It is clear who discovered him, however. Sometime in 1937, the West Chester art critic Christian Brinton became aware of Pippin. Some accounts say that the principal of the local school, where Pippin's stepson studied, introduced Brinton to Pippin. Another story states that Brinton noticed one of Pippin's paintings when it was displayed in a nearby restaurant. Yet another involves a young reporter alerting the art critic after passing two Pippin paintings displayed in the window of a shoe-repair shop. But regardless of how Brinton first came upon Pippin's work, one thing is clear: he was intrigued. Visiting the Pippin home, Brinton watched Pippin painting and decided that here—right in his backyard—was a brand-new talent.

Pippin was certainly not a "new" artist, as he had been working for nearly a decade. But to the art world of 1937—and that of our own time, too—what mattered was being "seen." After witnessing Pippin in action and observing his work, Brinton discussed it with a local painter, Nathaniel C. Wyeth. In record time, they decided that Pippin should

The Great Depression

The Great Depression of 1929-1939 is a period that fundamentally shaped American history. Millions of Americans went hungry, and many others were homeless during this difficult time. Though it may be surprising, the 1930s did not seem any worse than previous decades to the Pippin family since, as African Americans, they were accustomed to hard times. Pippin worked steadily on his art during this time. Visitors to the Pippin home commented on the sparseness of its furniture, but also its cleanliness. Jennie Pippin was a formidable home keeper.

be included in a show of local painters, scheduled for the summer of 1937.

The Emancipator

Pippin's lifelong fascination with Lincoln continued to spill over into his work. In *Abe Lincoln: The Great Emancipator*, Lincoln stands in the foreground of a military tent. All his attention goes to a young man, on his knees before him. Has this young soldier committed a crime? Has he wronged his fellows? About all we can say for certain is that he is likely to be pardoned. This is how Pippin saw Lincoln, and it tells us much about his idea of what constitutes proper, or upright, leadership.

62 HORACE PIPPIN: Painter and Decorated Soldier

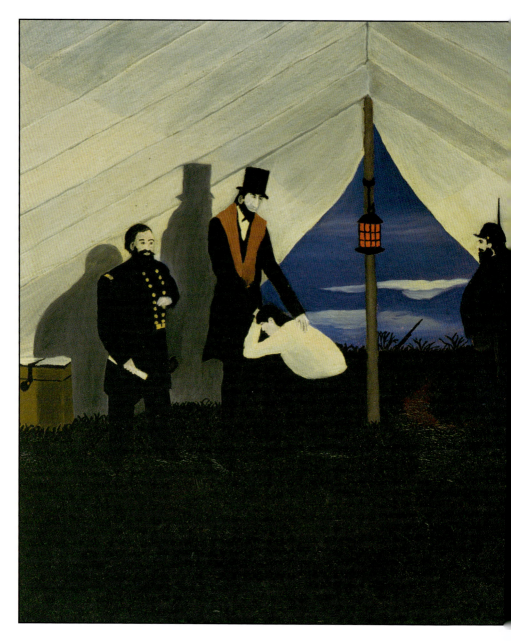

The Great Emancipator (1942)

Road to Discovery

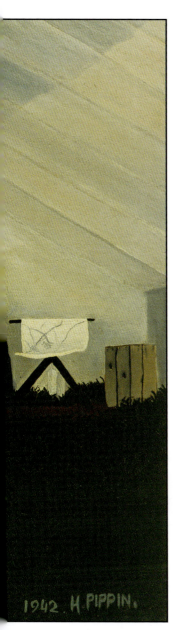

First Response

Local newspapers commented on the early public appearance of Pippin's paintings. *The Coatesville Record*'s "Market Scribe" specifically noted Pippin's lack of formal artistic training but was forced to admit that there was a "touch of genius" to Pippin's painting.[1] The word "primitive" was used to describe his art, and, for better or worse, that adjective stuck, becoming the label most often associated with Pippin's work.

But Pippin's lack of training did not stop him from succeeding: In that first art show, Pippin's work gained two honorable mentions, and local dealer Albert C. Barnes took an interest. Art critics and dealers quickly became keen to show Pippin's work. At the same time, they wanted to see more, to establish that this unschooled painter hadn't just lucked into producing a couple of interesting pieces. Pippin happily obliged.

Pippin had many artistic talents, but his depiction of home life is perhaps his most successful. In *Domino Players*, a young boy looks on rather morosely, while his mother, grandmother, and perhaps aunt play dominoes on the kitchen table. There is a hint of sadness in the busy family.

64 HORACE PIPPIN: Painter and Decorated Soldier

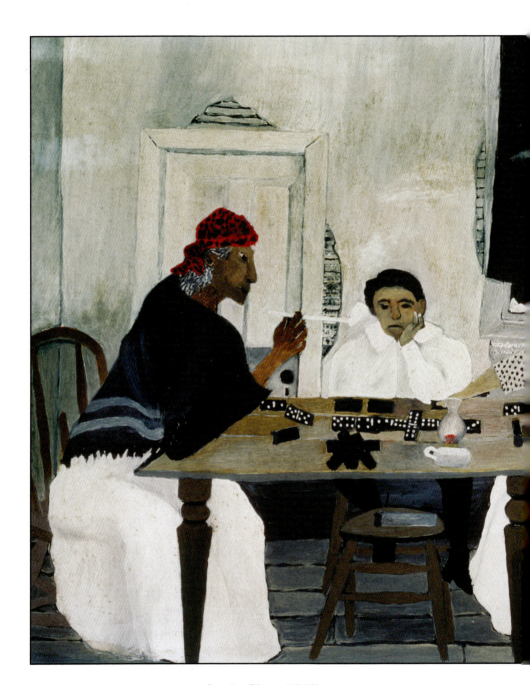

Domino Players (1943)

Road to Discovery 65

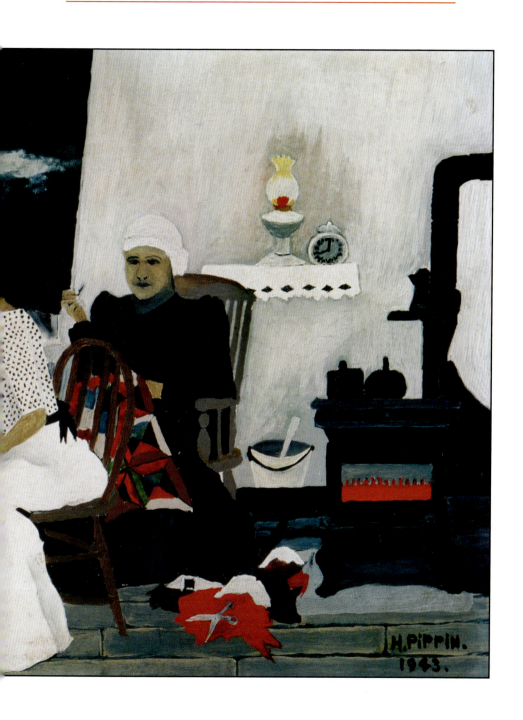

HORACE PIPPIN: Painter and Decorated Soldier

Pippin had great admiration for the leading women in his life. His autobiography describes his mother's heroism in detail. But there was melancholy over the lack of leading male figures. Very likely, this is why service in the First World War was so pivotal for Pippin: it allowed him to become more of a man in his own eyes.

In *Christ and the Woman of Samaria*, Jesus is portrayed quite differently. Relying on a richly colorful palette, Pippin depicts a hale and healthy Jesus in the months prior to his arrest and crucifixion. The sky is alight with a pink-shaded sunset, and Jesus's simple robe is a vivid purple, alluding to the color of royalty. He meets a Samaritan woman at the well and engages in conversation with her. This alone is strange to the viewer, who, like the reader of the Bible, knows that the Samaritans were not Jews. There was no reason Christ would talk with this woman, except that he was Christ. Three large trees provide shelter for Jesus, who stands at center left. The well occupies the direct center of the painting, with the Samaritan woman to

Road to Discovery 67

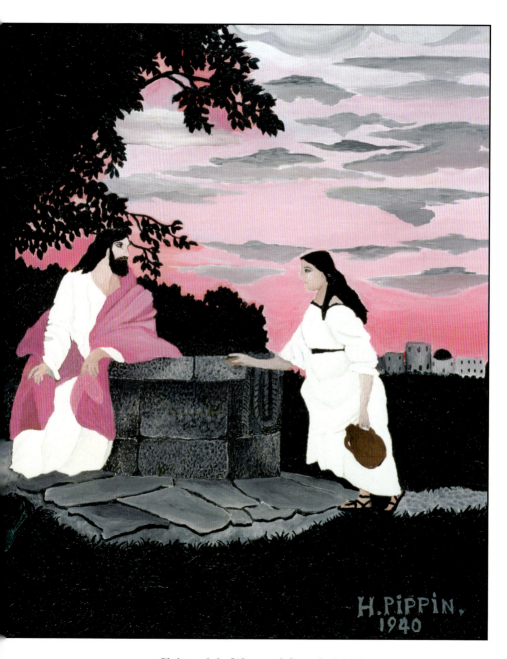

Christ and the Woman of Samaria (1940)

The Approach of World War II

Germany went to war with its European neighbors in September 1939, annexing and invading several nations. But the United States stayed out of the Second World War until the bombing of Pearl Harbor by the Japanese on December 7, 1941. With its clear villains and heroes, World War II was easier to understand than World War I, which was triggered by a single assassination but which swept up the entire world in a complex, woefully destructive and, according to many historians, largely unnecessary battle. For his part, Pippin never spoke publicly about World War II, but one suspects he was dead set against it. Having experienced the terrors of trench warfare in 1918, he had become a pacifist.

the right. The viewer guesses that Pippin intends the well to represent Christ and the hope of heaven, a hope that had given him strength in his own dark hours.

Chapter 8

Dealing with Race

One of Horace Pippin's great skills was his understanding of himself, a fact made clear by his self-portrait. At ease, shirtsleeves rolled and in a casual pose, Pippin comes across as completely unaffected, and that aims straight for his point. Unconcerned with formality, he is entirely focused on his work. This focus would soon pay off.

As the 1930s yielded to the 1940s, Pippin was reaching the pinnacle of his artistic success. He had already established himself as a prolific painter who could take on a variety of subjects. The beginning of the new decade found his art in demand and ever-increasing notice of it in newspapers and magazines.

Though this success was impressive for any artist, there was no escaping that the recognition was especially impressive for a black artist without any training. Pippin's particular style, not shaped by art school, had its own unique appeal—but the nature of the admiration that he earned was a bit of a mixed blessing.

70 HORACE PIPPIN: Painter and Decorated Soldier

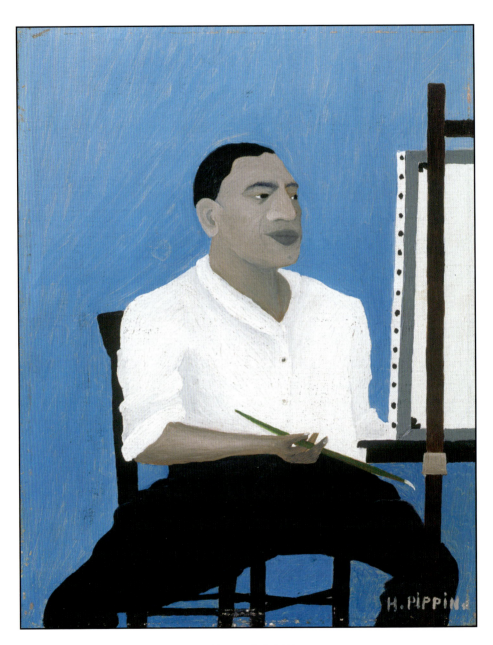

Self-Portrait (1941)

The "Primitive" Label

When Pippin's art was first tagged with the "primitive" label, it appeared to suggest praise more than condemnation. It was a way of including untrained artists in the exclusive world of art, one that could be hostile to those who had no background in art education. Quite a few dealers in art actively sought for "primitive painters," eager to find these natural talents who had come to their art entirely on their own, without the benefit of schooling.

But for most of us today, in the twenty-first century, "primitive" has understandably negative connotations. It has the air of condescension, suggesting that any untrained artist's skill is inherently primitive, or unsophisticated, and the term becomes especially loaded when referring to an African American artist. As a black artist in the 1930s and 1940s, the grandson of slaves, Pippin would never have had the opportunity to formally study art. Thus the standard of what constituted great art had been defined primarily by white Europeans; it's easy to see how labeling anything not in this tradition as "primitive" would be more than a little problematic. While "primitive" may have been understood as a compliment at the time, it certainly seems like a backhanded one at best. Of course, Pippin himself was largely unaffected by this label and, in fact, he had a complicated relationship with the portrayal of race.

Race Relations in Art

Occasionally, Pippin faced criticism by members of the African American community. How could a person of such skill paint mostly natural and religious scenes, rather

A pencil sketch of *After Supper, West Chester* (1935)

than ones that spoke to the persecution endured by black Americans, they asked? Pippin, generally, did not feel the need to answer this question. Few people knew the pain of racial segregation better than he, having endured it through the First World War. Though he did not often express his

Dealing with Race 73

views, Pippin made his most direct statement about race in *After Supper, West Chester*.

Painted around 1935, *After Supper* shows two late-nineteenth-century homes standing within 30 feet (9 meters) of each other. These are old-fashioned homes, the type Pippin had grown up in. A wooden fence about 4 feet (1.2 m) high connects the space between them. The houses provide the background; the foreground is taken up by two older girls, two grandmothers, and an assortment of children and dogs.

The two older girls—one white and the other black—meet in dead center of the painting. Each raises her arms to play "London Bridge," creating a tripod effect that is completed by a teenage boy beneath. Each girl has a large hat, or bonnet, tied to her neck, but the effect of the hats is to create the look of an angel looking over their shoulder. Children play in the foreground, while each

grandmother—one white and the other black—sits in a chair, observing with contentment.

So far as Pippin was concerned, *After Supper* said it all. A society marked by integration, and, presumably, love would one day emerge. In the meantime, people of goodwill had to do all they could to encourage its arrival.

Though Pippin's vision of pure equality was forward thinking, he wasn't only concerned with the future. The early 1940s saw him engage in a sustained effort at depicting historic scenes, paintings that do suggest an indirect but significant position about race, many of them from eighty years in the past.

Memorializing History

The painter who takes on historic subjects often has greater scope than he who paints the present. At the same time, that painter is often judged by the accuracy, or lack thereof, in his work. Pippin knew he could not please all viewers. The work was important enough for him to make the attempt, however.

Of all nineteenth-century white Americans, African Americans felt the closest connection with John Brown (1800–1859) and President Abraham Lincoln (1809–1865). Pippin went to work on John Brown, the abolitionist and martyr who attempted to free black slaves by seizing the federal arsenal at Harpers Ferry in 1859. Though less explicit than the racial utopia presented in *After Supper*, Pippin's choice of Brown—who was still not viewed as an unequivocal hero—as a subject could be interpreted as a subtle challenge to white viewers to reflect upon Brown's moral courage.

A Family Legend

Pippin told Robert Carlen, his art dealer, that his mother had witnessed the execution of John Brown and that he used her experience to inform his justly famous painting. Subsequent research suggests it was Pippin's *grandmother*. Though there's precious little biographical detail about Pippin's grandmother available, it's certain that she was a slave. John Brown's public hanging, a severe punishment for attempting to unite and free slaves, would have had a profound effect on her. Viewing the woman in the painting, her back defiantly turned against the spectacle of death, there is little doubt that the Pippin family felt a strong connection to the sensational event.

Returning to Lincoln

Having completed his John Brown trilogy, Pippin once again turned his attention to Abraham Lincoln, completing *Abe Lincoln's First Book* in 1944.

Abe Lincoln's First Book shows the teenage Lincoln in bed, in a cabin so rustic and dark that only one ray of light, coming from a solitary candle, illuminates the center of the frame. Lincoln has an enthusiastic look; his face—wrapped in the cares of adolescence—seems almost as female as male. In his upraised left hand, Lincoln grasps a book, presumably given to him by one of his parents. Pippin never commented to any great degree on this painting,

and he did not need to. The power of knowledge, which accompanies the light from the candle, is clearly evident. As the young Lincoln saw a way forward through his beloved books, it's not hard to imagine a young Pippin similarly empowered by his early drawings.

Though it would take many years for Pippin's early love of art to pay off, when it did, his work flourished. The early 1940s were an especially good time for Pippin. His art had advanced to where he was often hailed, sometimes as a primitive and sometimes as a self-taught naturalist. His paintings earned more money than in previous years. And even though the nation was embroiled in the Second World War, Pippin—as a wounded veteran—could not be summoned to serve again.

The same was not true of his stepson.

Chapter 9

Troubles at Home

Horace Pippin's career burst on to the American art scene in the early 1940s, during the same years that the United States fought Germany in World War II. The only connection that Pippin saw between the two events was his earnest desire for his family to stay out of the war. This was not a concern for Pippin himself: he was far too old for military service. His stepson, Richard Wade, on the other hand, was in young manhood and a prime candidate for induction to the US armed forces.

Conflicts with His Wife

Pippin generally emphasized the positive aspects of his marriage and family life. There is little doubt that Jennie Wade came into his life at the right time or that she provided much-needed stability in the decade that followed their wedding. Nonetheless, outside observers noticed tensions in the marriage by about the year 1940.

To many, it seemed odd that Jennie Wade Pippin did not quit her laundry business. Surely this was unnecessary when

HORACE PIPPIN: Painter and Decorated Soldier

her husband's paintings were selling so well, they suggested. But every person that offered up this idea was promptly shot down. Jennie Pippin believed her husband's art success was a flash in the pan, which could depart as suddenly as it came. She, therefore, continued to take it laundry, as well as to do needlework.

One of the most interesting photographs of Pippin came in 1941, when he was profiled in *Friday* magazine. The photo shows Horace Pippin in the center of the living room, with his wife at the extreme right. He is reading the newspaper; she is stitching. To Pippin's right are his stepson and his stepson's wife, who appear to be in their early twenties. The photograph shows domestic stability, especially a husband and wife who work as a team. This does not jibe with outside reports, however; they record that Jennie was increasingly distressed and that she may have suffered from mental illness.

Troubles at Home 79

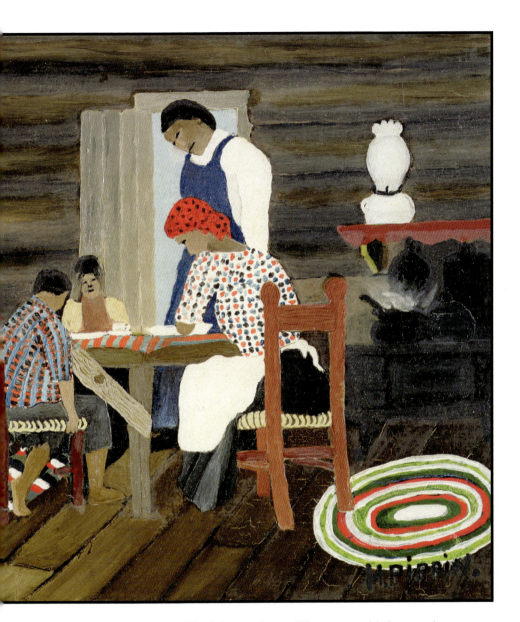

Giving Thanks (1942). Pippin's own home life was not this harmonious.

HORACE PIPPIN: Painter and Decorated Soldier

For his part, Horace had changed little over the years. Newspaper reporters invariably commented on his easygoing, relaxed manner and his quiet but profound religious faith. One of the bedrocks of that faith was nonviolence, a stance to which Pippin had converted in the aftermath of World War I. It was why he was deeply distressed when his stepson entered the US Army in 1942.

With their son fighting in the Pacific, the Pippins took on a lonelier appearance. The house looked the same, but Jennie was in poor health. Horace, on the other hand, sought relief in drinking at local bars. Throughout life,

Wartime Strains on Marriage

Many films and documentaries of the Second World War emphasize how, alongside national pride, the war cultivated and promoted the duty to be relentlessly upbeat about the battles being waged overseas. Since their loved ones deployed across the world had enough to worry about, this duty fell on the folks "back home." Those that kept the home fires burning had an obligation to keep their spirits up, even in spite of the dislocation that many families suffered. The Pippin family was different only in that Pippin knew all too well the horrors that his stepson would be facing and opposed his service. It was Pippin's staunch disapproval of war combined with Jennie's deteriorating mental health that likely contributed to the strain on their marriage.

Troubles at Home 81

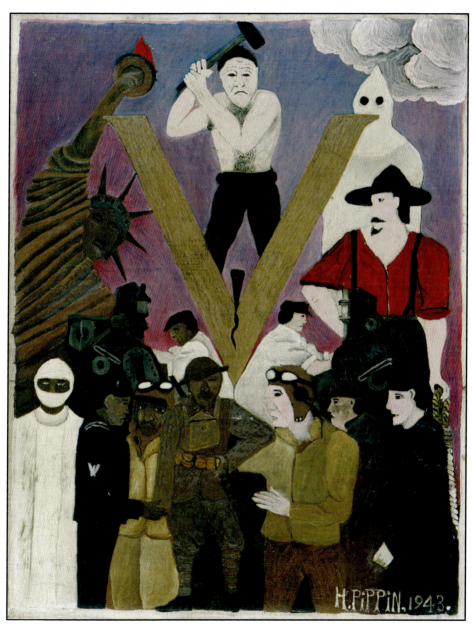

Mr. Prejudice (1943)

he had often enjoyed a good mug of beer, but his intake of alcohol doubled and even tripled in 1944 and 1945. It is likely, too, that he was occasionally unfaithful to his wife. But even in the midst of this familial conflict, Pippin continued to paint.

Mr. Prejudice

Pippin usually liked to make his own decisions where art was concerned, but the advent of World War II forced his hand. Many African Americans complained bitterly about the treatment they received, both at home and while serving in the army or navy. Pippin, of course, knew these conflicts—and miseries—firsthand. Though he never named names, it seems likely that friends, as well as patrons, pushed him to paint a major work that more directly commented on race relations. *Mr. Prejudice* was the result.

Completed in 1943—the year that saw America and its allies turn the tide against Germany and Japan, *Mr. Prejudice* is one of Pippin's most complex paintings. At dead center stands a prominent V. Slightly in the background is a grim-faced white man whose mallet, or sledgehammer, is about to break a hole in the meeting of the V. To the left of the V are mostly African American figures, while white Americans form the right-hand side. If this were all, *Mr. Prejudice* would be mildly disturbing. But when one adds the hooded Klansman and the sinister man in a red shirt who holds a noose, *Mr. Prejudice* becomes a truly terrifying vision of American society gone wrong. It is a far cry from the optimistic scene Pippin depicted in *After Supper, West Chester*.

Most reviews were negative. White art critics believed Pippin had lost his way, while African Americans, generally, believed he had not gone far enough. Very likely, this is why Pippin had so long avoided making this kind of art. The response to *Mr. Prejudice* confirmed his opinion that producing polarizing political art wasn't for him. Fortunately, Pippin was about to embark on the most productive twenty-four months of his entire career.

The Full Flower

We often use images from nature to describe moments in a career. In Pippin's case, the full flowering of his art came in 1944–1946. During those two years, Pippin worked with incredible intensity, rapidly turning out one painting after another. It is possible that his right arm had regained much of its earlier strength. It is also possible that Pippin felt the need to erase his "failure" with *Mr. Prejudice*. What we can say, with great confidence, is that Pippin broke down the separations and divisions of his earlier career; between 1944 and 1946, he painted on any number of topics.

In 1944, Pippin painted *Self-Portrait II*. Here, Pippin looks—almost for the first time—as a person of marked success. He wears a dark-brown suit, and his yellow-brown tie gives off an air of sophistication and financial success. One wonders how comfortable Pippin was in this role, however. He had usually been portrayed, or captured, in comfortable, casual clothing. One can almost hear him saying that it is a sacrifice to dress up like this—that it makes him a different person.

84 HORACE PIPPIN: Painter and Decorated Soldier

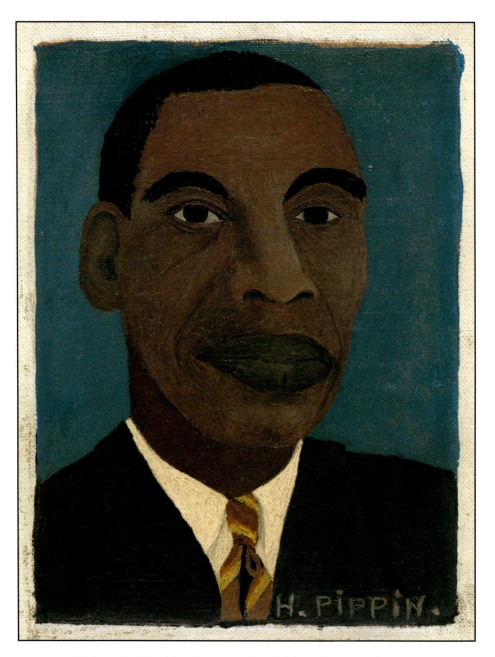

Self-Portrait II (1944). Pippin depicted himself as a serious and successful, but not very happy, artist.

Christian Connections

That Pippin was a deeply committed Christian was obvious to all who spent time in his presence. Pippin quoted from the Bible at length and in depth. He seldom spoke of any divine mandate, but late in his career he confided to a friend or two that he had the vision of what to paint and that Jesus then directed him in his work. If true, this helps explain his emphasis on religious motifs and belief, as well as his clear appreciation for nature and his horror at the senseless wars waged by men.

The Peaceable Kingdom

Pippin liked to work in series, painting two, three, or even four canvases on the same theme. The last theme he took up was the "Peaceable Kingdom." Here, Pippin worked with a previously established motif. The Peaceable Kingdom, where the lions and tigers lie down with donkeys and sheep, had been painted many times by the nineteenth-century Pennsylvania artist Edward Hicks. Pippin was not content to imitate, however. He painted the *Peaceable Kingdom* in the context of World War II's end, and to a group of friends, he wrote a description, emphasizing that despite all the bad things they—and Americans as a whole—experienced, there would be peace one day.

Chapter **10**

A Sudden End

At the beginning of 1945, there was little, if any, sense that Pippin would soon die. He looked as hale and hearty as he always had. Friends marveled at his physical strength and moral continuity, to which he replied that years of manual labor had been good for him—they steeled him for what was to come. But his health was not as strong as it seemed.

Rediscovering His Roots

In 1944 and 1945, Pippin's mind returned to scenes from his early life. He did not travel to Goshen, New York, but he corresponded with old friends there to a greater degree than in the past. His art, too, showed a renewed concern with his personal history.

A Sudden End 87

Harmonizing (1944)

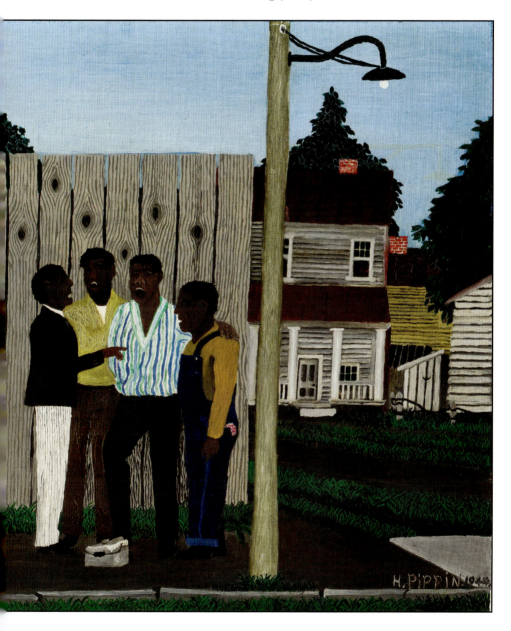

Harmonizing is one of Pippin's most surprising works. He was so solitary and self-reliant, that it is unusual to think of him in the context of a singing group. But in this painting, Pippin depicts four African American men, all under the age of forty, delivering a joyous, and perhaps spontaneous, song, right in front of one of the white picket fences for which Chester County, Pennsylvania, is justly famous.

The Last Painting

A few months before he died, Pippin painted *Man on a Bench*. The bench could be anywhere in Goshen, New York; West Chester, Pennsylvania; or even Paris. What matters is not the location, but the man's presence of mind. Though he is surrounded by bright leaves and an animal happily romping in the background, his eyes are downcast, detached from the scene around him.

Some viewers claim it is a painting of deep despair, that the subject cannot get out from under the weight of his thoughts. Others declare that it is a painting of wistful melancholy, a longing for something that has passed, not the same as despair. Still others point to those rich leaves of autumn, above and beyond, as signs that this state, or condition, will not last forever.

Did Pippin have premonitions of his own death? The record suggests he did not. But he had to confine his wife to a mental institution in February 1946, and his own depression subsequently deepened. Thankfully, we possess some of his last letters, written in the spring and summer of 1946, which give some insight into his state of mind.

Letters Home

On June 27, 1946, Pippin wrote a letter to "My Friends." He addressed the letter to the Goshen Library and dropped in in a mailbox.

"To my friends in Goshen," he began. "You know that I said that I would be in Goshen this spring but I can not do so at this time for my wife is in the hospital, she has been there from March 16th 1946 but I am glad that every one likes the pictures."[1] This was a roundabout way of admitting that his wife was in very bad shape. In a letter the year before, sent to his art dealer, Pippin had been more explicit, saying that his wife was not herself. "Dear friends," Pippin continued, "put them where every one could see them as soon as my wife comes home I will come and see you all it may be soon."[2] That day did not come.

Horace Pippin died in his sleep on July 6, 1946. The cause of death was determined to be a stroke. Jennie Pippin never learned of her husband's death. She died in the mental institution two weeks later.

A Difficult Marriage

Pippin was much too proud a person to comment publicly on his marriage. Only in the occasional letter, sometimes to his art dealer, did Pippin confide something of the difficulties. To the best of our knowledge, Jennie Pippin suffered some type of mental illness, and this was exacerbated by amphetamines, which she took in order to lose weight.

Examining an Unfinished Life

How, one wonders, could so strong and vital a person die so suddenly? Though he suffered residual pain from his war wounds, Pippin nearly always seemed in good health. Years of hard physical labor made him exceptionally strong, and all the years of painting never produced a stoop or even rounded shoulders. But, all too suddenly, he was gone.

Pippin's wife's death, so soon after his own, meant that the family was winnowed down to his stepson, Richard Wade. Richard served in the US military in World War II and returned to Chester County, Pennsylvania, where he spent the rest of his life. Pippin still had friends and relatives in Goshen, New York, but he had no one to put all the pieces in order, to demonstrate how remarkable his life and career had been. Lacking a curator, or archivist, in the family, it is left to us, Pippin's viewers, to come up with a summary.

The first and most important question is: Was Pippin truly self-made? And the answer is an absolute, unqualified yes. Pippin forged his own art, as he sought to escape the trauma of the First World War. And though his paintings took him to many other places—literal and figurative—he remained, to some extent, a captive of his World War I experience.

The second great question is: Did Pippin see himself as American or African American? And the answer is that his African American identity was so deep, so profound, that he did not need to emphasize it. He was African American, the son of a single mother, the breadwinner from an early age, the self-made man who established his own path.

Anyone who doubts the core of Pippin's black roots need only examine any of the paintings of his childhood.

The third great question has to do specifically with art, as opposed to race or ethnicity: Did Pippin break new ground?

This one is more complex than the previous two. Pippin certainly used imagery from advertisements and popular culture, but he used them in ways that were distinctly his. No other American painter—black or white—delineated the World War I experience, the 1930s and 1940s, and managed to summon up his childhood, all in one career. One need only look at the totality of Pippin's career to conclude that he was a self-made black artist who broke entirely new ground in the world of art.

Chronology

1888

Horace Pippin born in West Chester, PA.

c. 1895

Pippin has his first experience drawing.

1908

Pippin's mother dies.

1912

Pippin moves to New Jersey.

1914

World War I begins in Europe.

1915

Pippin becomes an iron molder.

1917

The United States enters World War I, as one of the Allies; Pippin enlists in the New York Fifteenth Regiment.

1918

The New York Fifteenth becomes the US 369th; the 369th fights on the defensive in spring and summer, goes on the offense in autumn; Pippin is seriously wounded on September 29 or 30; World War I ends on November 11.

1919

369th Regiment returns home; Pippin receives honorable discharge.

1920

Pippin marries Jennie Wade.

1925

Pippin visits Durham, North Carolina.

1929

Pippin experiments with burned wooden prints.

1930

Pippin finishes *The End of the War: Starting Home*.

1930-1935

Pippin executes many paintings of natural scenes.

1935

After Supper, West Chester is Pippin's most direct commentary on race at this point in his career.

1937

Pippin paints portrait of Marine Corps major general; Pippin is discovered by art critic and art dealer in Chester County.

1939

World War II begins in Europe.

1940

Christ and the Woman of Samaria introduces Pippin as a religious painter.

1941

The United States enters World War II; *Christ Before Pilate* has modern, as well as ancient, themes.

1943

Pippin brings out *Mr. Prejudice*, which earns few fans.

1945
The Milkman of Goshen brings Pippin—and the viewer—to his childhood.

1946
Man on a Bench is Pippin's last known work; Pippin commits his wife, Jennie, to a mental institution; Pippin dies on July 6. Jennie dies two weeks later.

Chapter Notes

Chapter 1
The Youth of an Artist

1. Horace Pippin, "My Life's Story," in *Horace Pippin: A Negro Painter in America* by Selden Rodman (New York, NY: The Quadrangle Press, 1947), p. 77.
2. Ibid.
3. Ibid.
4. Ibid.
5. Pippin, p. 78.
6. Ibid.

Chapter 2
Life as a Black Soldier

1. Celeste-Marie Bernier, *Suffering and Sunset: World War I in the Art and Life of Horace Pippin* (Philadelphia, PA: Temple University Press, 2017), pp. 87–89.
2. Peter N. Nelson, *A More Unbending Battle: The Harlem Hellfighters' Struggle for Freedom in World War I and Equality at Home* (New York, NY: BasicCivitas, 2009), p. 36.

Chapter 3
The Most Traumatic Day

1. Scott Berg, ed., *World War I and America: Told by the Americans Who Lived It* (New York, NY: Library of America, 2017), p. 587.
2. Ibid.
3. Berg, p. 588.
4. Ibid.
5. Ibid.

Chapter Notes

Chapter 4
A Painful Return
1. Horace Pippin notebook, circa 1920. Archives of American Art, Smithsonian Institution.
2. Celeste-Marie Bernier, *Suffering and Sunset: World War I in the Art and Life of Horace Pippin* (Philadelphia, PA: Temple University Press, 2017), p. 246.
3. Ibid.
4. Selden Rodman, *Horace Pippin: A Negro Painter in America* (New York, NY: The Quadrangle Press, 1947), p. 79.

Chapter 6
An Evolving Style
1. Selden Rodman, *Horace Pippin: A Negro Painter in America* (New York, NY: The Quadrangle Press, 1947), p. 4.

Chapter 7
Road to Discovery
1. Judith E. Stein et al., *I Tell My Heart: The Art of Horace Pippin* (Philadelphia, PA: Pennsylvania Academy of Fine Arts, 1993).

Chapter 10
A Sudden End
1. Celeste-Marie Bernier, *Suffering and Sunset: World War I in the Art and Life of Horace Pippin* (Philadelphia, PA: Temple University Press, 2017), p. 402.
2. Ibid.

Glossary

barracks Military sleeping quarters for soldiers.

condescension An attitude that treats other people as though they are less capable or intelligent.

dogfight An aerial conflict between aircraft during war.

draft Mandatory service in the military.

melancholy A sense of sadness without an apparent cause.

narrative art Art that tells a story through the construction of a scene that is unfolding before the viewer.

naturalism A style of art focusing on everyday events and objects.

nostalgia The desire to re-create or return to the past.

pacifist A person who opposes the fighting of wars.

palette A collection of colors used in the creation of an artwork.

polarizing Drawing a strong reaction from people on both sides of an issue.

post-traumatic stress disorder (PTSD) A state of deep shock and horror that continues after an initial traumatic event is over.

primitive art Work done by an artist without formal training; sometimes called "naive art."

Further Reading

BOOKS

Bernier, Celeste-Marie. *Suffering and Sunset: World War I in the Art and Life of Horace Pippin.* Philadelphia, PA: Temple University Press, 2017.

Bryant, Jen. *A Splash of Red: The Life and Art of Horace Pippin.* New York, NY: Random House, 2013.

Lewis, Audrey, ed. *Horace Pippin: The Way I See It.* New York, NY: Scala Arts Publishers, 2015.

Randolph, Joanne, ed. *African American Artists & Writers.* New York, NY: Enslow Publishing, 2018.

WEBSITES

Horace Pippin–Artwork
https://www.the-athenaeum.org/art/list.php?m=a&s=tu&aid=4908
A collection of Horace Pippin's artwork.

Horace Pippin–Biography
https://www.biography.com/people/horace-pippin-9441456
A brief biography of Pippin, charting his artistic trajectory.

Horace Pippin's Notebooks & Letters, 1920-1943–Smithsonian Archives of American Art
https://www.aaa.si.edu/collections/horace-pippin-notebooks-and-letters-8586
Pippin's notebooks and letters containing his reflections on the First World War.

Select List of Works

Abe Lincoln's First Book (1944), Carnegie Museum of Art (Pittsburgh, PA)

Bear Hunt I (1930), Chester County Historical Society (West Chester, PA)

The Buffalo Hunt (1933), Whitney Museum of American Art (New York, NY)

Christ and the Woman of Samaria (1940), the Barnes Foundation (Philadelphia, PA)

Christ Crowned with Thorns (1938), Howard University Gallery of Art (Washington, DC)

Dog Fight Over Trenches (1935), Hirshhorn Museum and Sculpture Garden (Washington, DC)

The End of the War: Starting Home (1930), Philadelphia Museum of Art (Philadelphia, PA)

John Brown Going to His Hanging (1942), Pennsylvania Academy of the Fine Arts (Philadelphia, Pennsylvania)

Losing the Way (1930), State Museum of Pennsylvania (Harrisburg, PA)

Mr. Prejudice (1943), Philadelphia Museum of Art (Philadelphia, PA)

Self-Portrait II (1944), Metropolitan Museum of Art (New York, NY)

Index

A

Abe Lincoln: The Great Emancipator, 61
Abe Lincoln's First Book, 75–76
Abraham Lincoln and His Father Building Their Cabin on Pigeon Creek, 56–57
African Americans in early twentieth century, 7, 48, 69, 71, 72
 in military, 13, 16–21, 30, 33, 38, 43, 82
After Supper, West Chester, 73–74, 82
artist signatures, 56
Asleep, 38

B

Barnes, Albert C., 63
The Barracks, 46–48
The Blue Tiger, 49
Brinton, Christian, 60
Brown, John, 74, 75

C

Cabin in the Cotton, 52
Carlen, Robert, 75
Christ and the Woman of Samaria, 66
Christmas Morning Breakfast, 9

D

Domino Players, 63

E

The End of War: Starting Home, 42–44
Europe, James Reese, 17

F

French Fourth Army, 20–21, 24

G

Gavin, James, 9
Goshen, NY, 7–8, 12, 32, 39, 86, 88, 89, 90
Great Depression, 61

H

Harlem Hellfighters, 30
Harmonizing, 88
Hayward, William, 16
Hicks, Edward, 85

K

Keegan, John, 29

L

Lincoln, Abraham, 7, 53–57, 61, 74, 75–76

Losing the Way, 52

M

Man on a Bench, 88
Mr. Prejudice, 82–83
"My Life's Story," 8, 11

N

New York Fifteenth, 13, 16–20

O

Outpost Raid: Champagne Sector, 44–46

P

Peaceable Kingdom, 85
Pippin, Horace
 art in adulthood, 35–38
 death of, 89, 90
 discovered as artist, 58–68
 early interest in art, 8–9
 family, 7, 8, 9, 11, 12, 13, 16, 32, 57, 58, 66, 75, 76, 77–78, 80–82, 88, 89, 90
 as folk/primitive artist, 48, 63, 69, 71, 76, 90
 jobs held, 11–12, 30–32, 58–60, 90
 marriage and stepson, 32, 58, 77–78, 80–82, 88, 89, 90
 as pacifist, 80
 paintings of nature, 49–52
 paintings of war, 39–48, 49, 90, 91
 race and, 71–74, 82–83, 90–91
 religion and, 32–33, 66–68, 80, 85
 self-portraits, 69, 83
 sketches while in army, 18–19
 success and, 69, 76, 77, 78, 83
 in World War I, 13, 15–16, 18–21, 22–29, 32–35, 38, 39, 42, 48, 66, 72, 80
 wounded while in war, 24–29, 30, 32, 33–34, 35, 90
 writings of, 33–34, 89
 youth, 7–12, 57
Pippin, Jennie Wade (wife), 32, 58, 61, 77–78, 80–82, 88, 89, 90

S

Self-Portrait II, 83
Shell Holes and Observation Balloon, 25–26
shell shock/PTSD, 25

T

369th Regiment, 20–21, 24, 30

Index

U
USS *Pocahontas*, 18

W
Wade, Richard (stepson), 32, 58, 60, 76, 77, 78, 80, 90
West Chester, PA, 7, 32, 42, 60, 88
Wilson, Woodrow, 14–15
World War I, 13, 14–21, 22–29, 30, 32–35, 38, 39, 42–48, 66, 72, 80, 90, 91
 tanks and planes, 43
 trench warfare, 19, 35
World War II, 43, 68, 76, 77, 80, 82, 85, 90
Wyeth, Nathaniel C., 60

Charlotte Etinde-Crompton Samuel Willard Crompton

About the Authors

Charlotte Etinde-Crompton was born and raised in Zaire and came to Massachusetts at the age of twenty. Her artistic sensibility stems from her early exposure to the many talented artists of her family and tribe, which included master wood-carvers. Her interest in African American art has been an abiding passion since her arrival in the United States.

Samuel Willard Crompton is a tenth-generation New Englander who now lives in metropolitan Atlanta. For twenty-eight years, he was a professor of history at Holyoke Community College. His early interest in the arts came from his wood-carver father and his oil-painter mother. Crompton is the author and editor of many books, including a number of nonfiction young adult titles with Enslow Publishing. This is his first collaboration with his wife.